LEONEL MOURA
COMET

Leonel Moura
Comet
Edited by Bebot Association, 2019

Independently published

English language
All images are Public Domain

ISBN: 9781794216570

www.leonelmoura.com
www.bebot.pt/bebot/

The cover reproduces a print
created to promote the project of the Artificial Comet

Comet

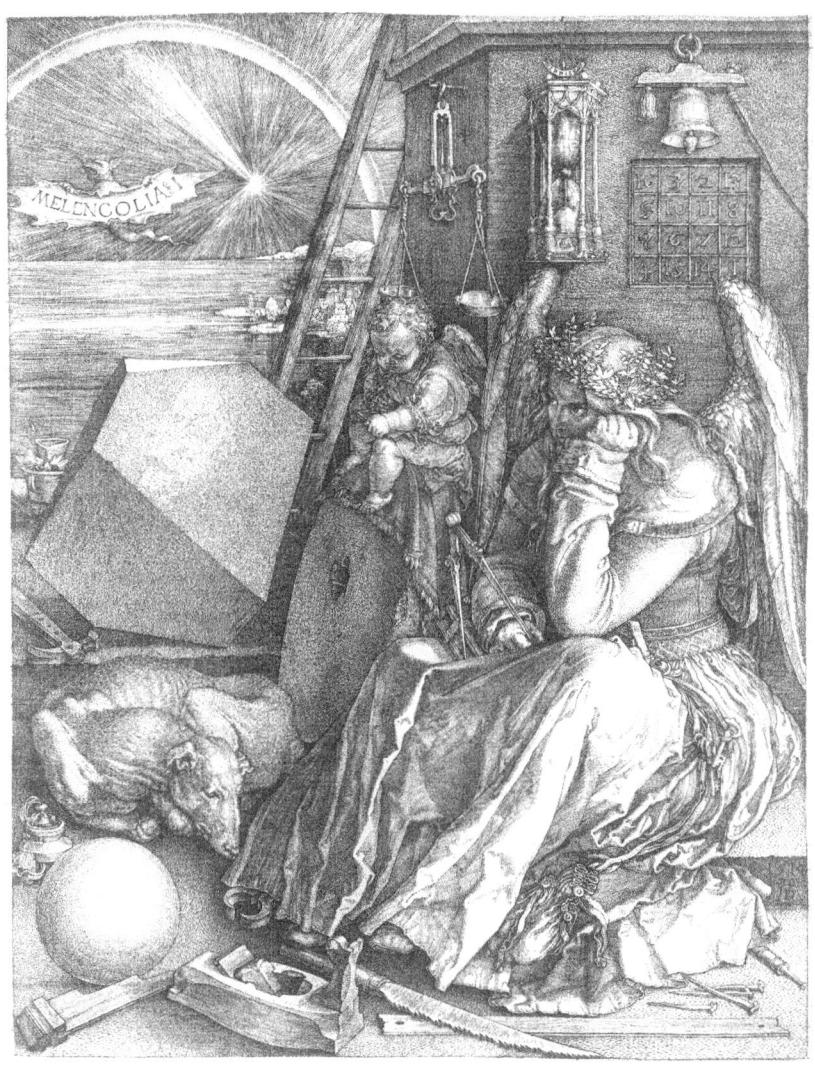

Albrecht Dürer, Melancholia I, 1515
The comet on top might have been inspired by the one observed at Christmas 1471, the year of Dürer's birth.

Leonel Moura

An Artificial Comet as an Artwork.

Comet

Imagine a bright line, like a shimmering brush stroke, crossing the dark skies at night. Is it an UFO? A falling satellite? No. It is an Art Work. An Artificial Comet.

My Comet is a plain concept. It intends to place a satellite in a circular orbit carrying a long tail of very reflective material. Something similar to those airplane advertisements that we often see in beaches but now in a much larger scale and ambition.

The dimension and length of the tail necessary to be seen for Earth surface, depends on the orbit height which at the lowest point can be around 160 km. The International Space Station orbits at a medium height of 400 km, it is 100 meters long and can be seen from Earth at naked eye. As for the tail material there are several possibilities available. Mylar for example can have a thickness of 0,05 millimetres and reflects 97% of light.

Hence, although technical solutions must be studied it is feasible.

Let us then launch an Artificial Comet to highlight the importance of space exploration and contribute to the unity of the inhabitants of our planet.

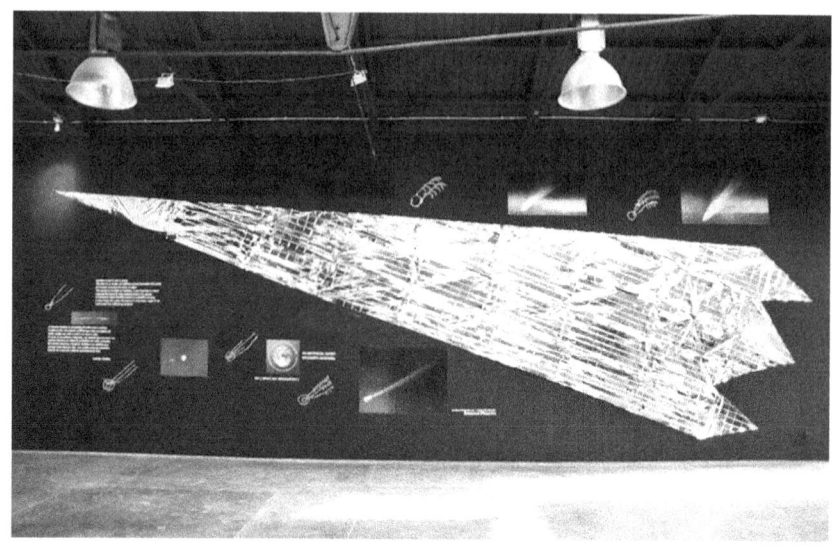

First exhibition of the project, Lxfactory, 2014.

Comet

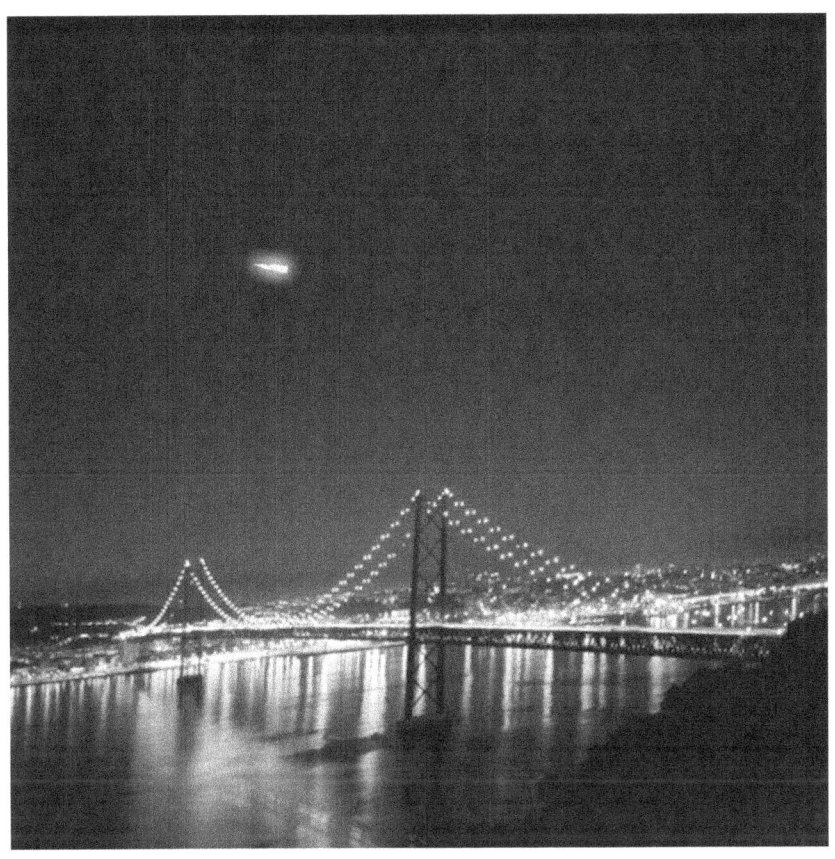

Preview of the Artificial Comet over Lisbon.

If we survive until then,
our passage to the next apparition
of Halley's Comet should be
comparatively easy.
That perihelion passage will be
in March 2134, when the comet
will make an unusually close
encounter with the Earth.
It will come as close as 0.09AU
or 14 million kilometers, less
than half the distance of
the 1910 encounter.
It will then be brighter than
the brightest star.
If there are those to do the
commemorating, the years 2061
and 2134 should be celebrated for
the courage, intelligence, and common
purpose of a species forced by urgent
necessity to come to its senses."

Carl Sagan, Ann Druyan, in Comet, 1997

Almost all of the space program's important advances in scientific knowledge have been accomplished by hundreds of robotic spacecraft in orbit about Earth and on missions to the distant planets Mercury, Venus, Mars, Jupiter, Saturn, Uranus, and Neptune. Robotic exploration of the planets and their satellites as well as of comets and asteroids has truly revolutionized our knowledge of the solar system.

James Alfred Van Allen, in 'Is Human Spaceflight Obsolete?', 2004

Leonel Moura

Most of what is called Space Art is mere illustration. From mediocre surrealist-like paintings to digital manipulation of Hubble images the panorama is dull. As an example, the Art depicted by NASA and ESA in their respective websites is really disappointing. Sceneries of imaginary planets with 3 moons or hypothetical extraterritorial worlds with colourful sunsets are not enough to define an art genre.

True Space Art means to work with or for the Space. Implies comprehending the challenges and enhance meaning through artistic creativity. This kind of understanding is very rare and I only know two artists worth mentioning: Joe Davis and Ted Kruger.

And yet, Space is a fascinating new territory for artistic creativity. It is enormous, unknown and inspiring. On the other hand, Space exploration needs desperately art. Not for design and bizarre visualizations, but for bold ideas and purpose. Such as it is the case of some projects developed by non-artists, mainly engineers and scientists. In the 1960's the Leningrad's engineer Yuri Artsutanov,

The concept of a space tower was first published in 1895 by Konstantin Tsiolkovsky.

proposed the construction of a space elevator connecting the ground to a geosynchronous satellite. It seems that he wasn't aware of the work of Konstantin Tsiolkovsky (1857-1935), considered one of the founding fathers of modern astronautics, whom years before had the idea of building a fantastic tower with the same purpose. Tsiolkovsky had this idea after seeing the Eiffel Tower in Paris. He only need to make one with 36 km high instead of 300 meters...

Leonel Moura

Konstantin Tsiolkovsky's idea for building a 36 km high Tower was published in 1895.

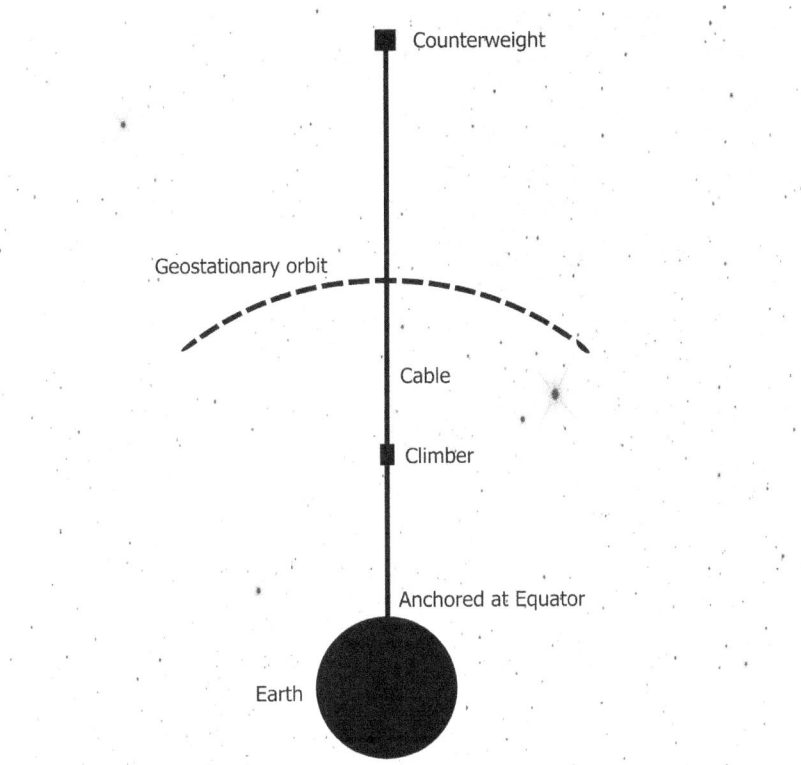

The space elevator is an idea from the Russian engineer Yuri Artsutanov.

Artsutanov project was different. The main component would be a cable attached to the surface extending into space beyond a geostationary orbit. A cable lift would make transportation of people and cargo very economical, enabling astronauts and robots to build satellite stations from which the universe could be explored. No more the expensive, dangerous and energy consuming

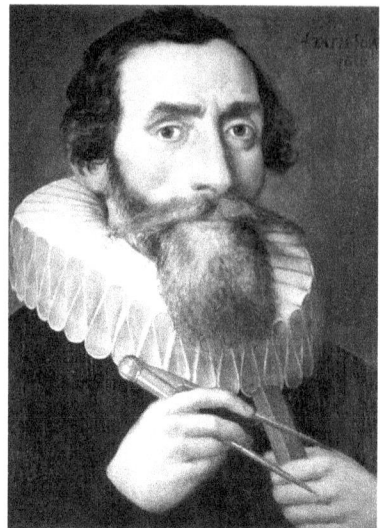

Johannes Kepler

rocket launching just to reach the escape velocity needed to get to orbit.

Space elevators were never built but they are object of intense debate and gave origin to several very active organizations, such as the International Space Elevator Consortium.

Solar sail is another very interesting scientific idea that fit the concept of Space Art. 17th century astronomer Johannes Kepler was the first to acknowledge solar winds by observing that comets always point their tails away from the Sun. He understood that some force was coming from our star. Since then the idea has made is way. In

1929 John Bernal wrote: "a form of space sailing might be developed which used the repulsive effect of the Sun's rays instead of wind." New materials, like Mylar, Kapton and others, which can be less than 0.1 micrometre thick, sustain the concept. 1 micrometre is 0.001 millimetre. Enormous sails can be deployed with just a few square meters of loading. These materials are also incredible reflective favouring solar breeze.

Space elevators and Solar sails are just two examples

Jules Verne

Isaac Newton

of scientific creativity not distinct from art creativity. So much that most people consider these "crazy" ideas science fiction. Thought that fiction is no more antagonist to science and it is now recognized as an evolutionary

Leonel Moura

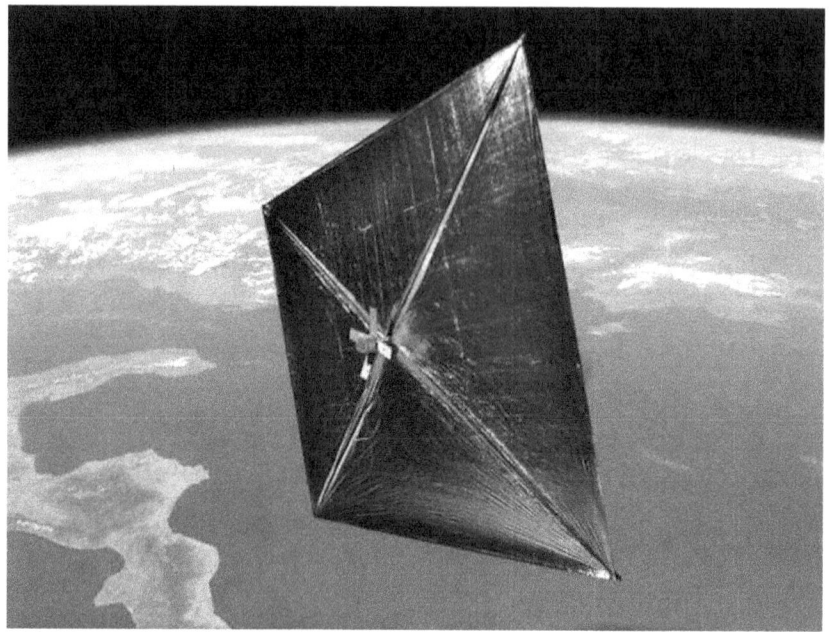

Solar sail. Image credit: NASA.

Comet

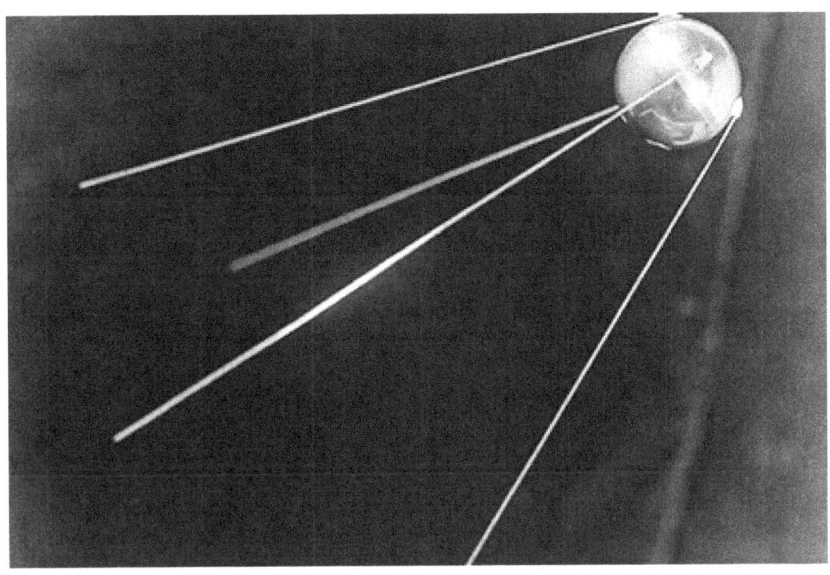

Sputnik 1, the first man-made artificial object was launched to space the 4 October 1957.

mechanism of scientific knowledge. For example, and keeping in the space realm, satellites appear in the 1879 Jules Verne novel "The Begum's Fortune" and in a 1945 article by Arthur C. Clarke "Wireless World" that talked for the first time of mass communication via the launching of a set of geostationary satellites which prove to be the case. Newton's cannonball concept (1687) can however be considered the first idea of an artificial satellite. On 4 October 1957 the launch by the Soviet Union of Sputnik 1, opened the race to conquer the extraterritorial space. It accelerated after that, in a political and technological race, as we know. Today there are almost 5,000 operational artificial objects orbiting the Earth. Counting dead satellites and small debris the number may exceed 500,000… How many made by artists? Zero. Or, to be nice, we may count the two Pioneer Plates launched in 1972 and 1973 on board of the space-crafts Pioneer 10 and 11. An engraving done by Linda Sagan, artist and wife of Carl Sagan showing nude figures of a human male and female along with several symbols that supposedly may provide directions to extra-terrestrial intelligence. Probably not a good idea, though.

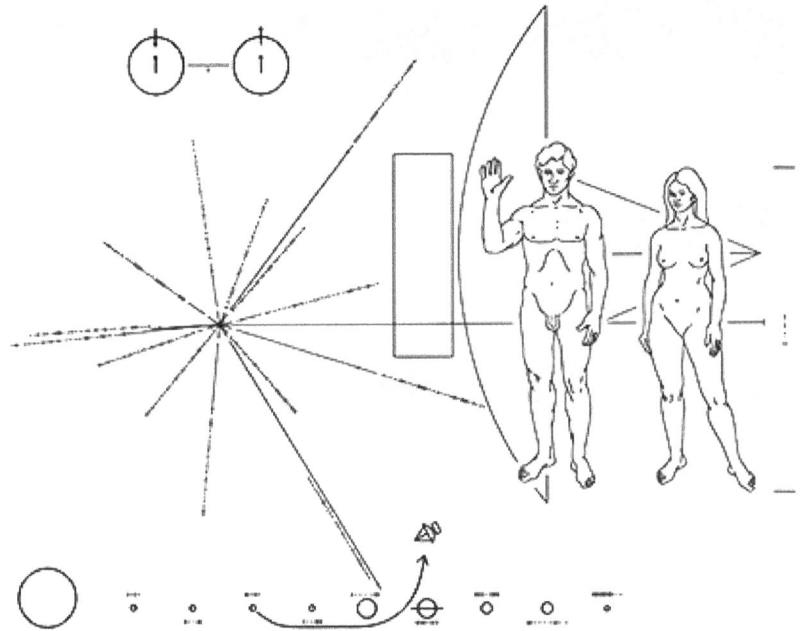

Despite criticisms of various aspects of the composition, such as the arrow or the sexual bias, the "Pioneer plaque" is certainly one of the most extraordinary art works from all times.

It is clear that artists should invest more in space. Being confined to the triviality of reproducing 19 and 20th century art is definitively not anymore very interesting. We need new challenges. Real talented people are stimulated by impossibility not by possibility. And the Space is the most open and large exploratory territory of the impossible that is within our reach.

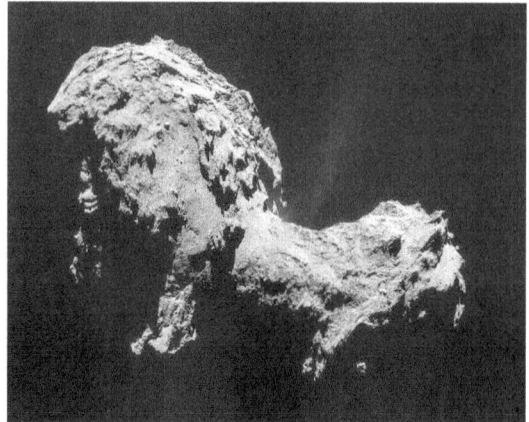
Comet 67P/Churyumov–Gerasimenko.

What is a comet?

A comet is an icy, small Solar System body that, when passing close to the Sun, warms and begins to release gases, a process called outgassing. This produces a visible atmosphere or coma, and sometimes also a tail.

Comet nuclei range from a few hundred metres to tens of kilometres across and are composed of loose collections of ice, dust, and small rocky particles.

Comets usually have highly eccentric elliptical orbits, and they have a wide range of orbital periods, ranging from several years to potentially several millions of years. As of July 2018 there are 6,339 known comets.

Source: Wikipedia

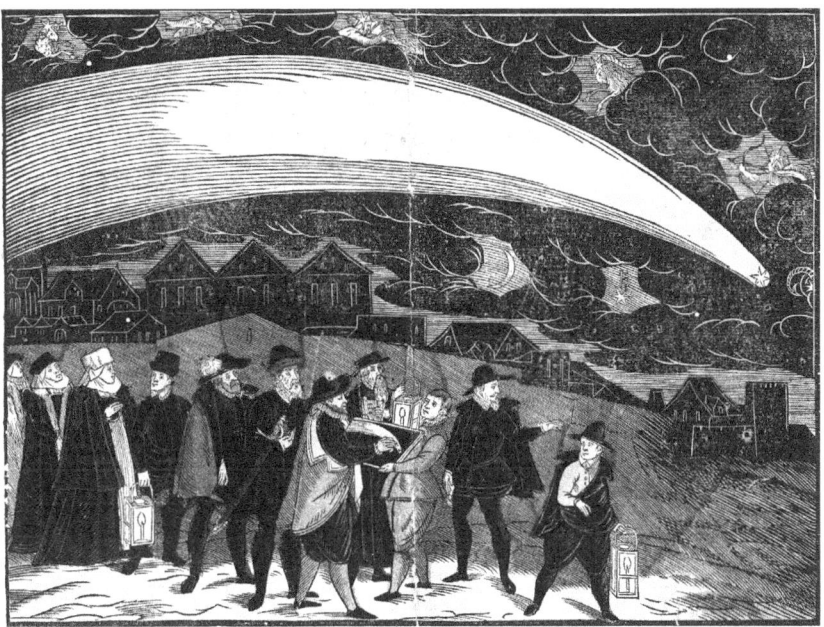

"*About a terrible and marvellous comet as appeared the Tuesday 12 November 1577*". Engraving by Jiri Daschitzsky.

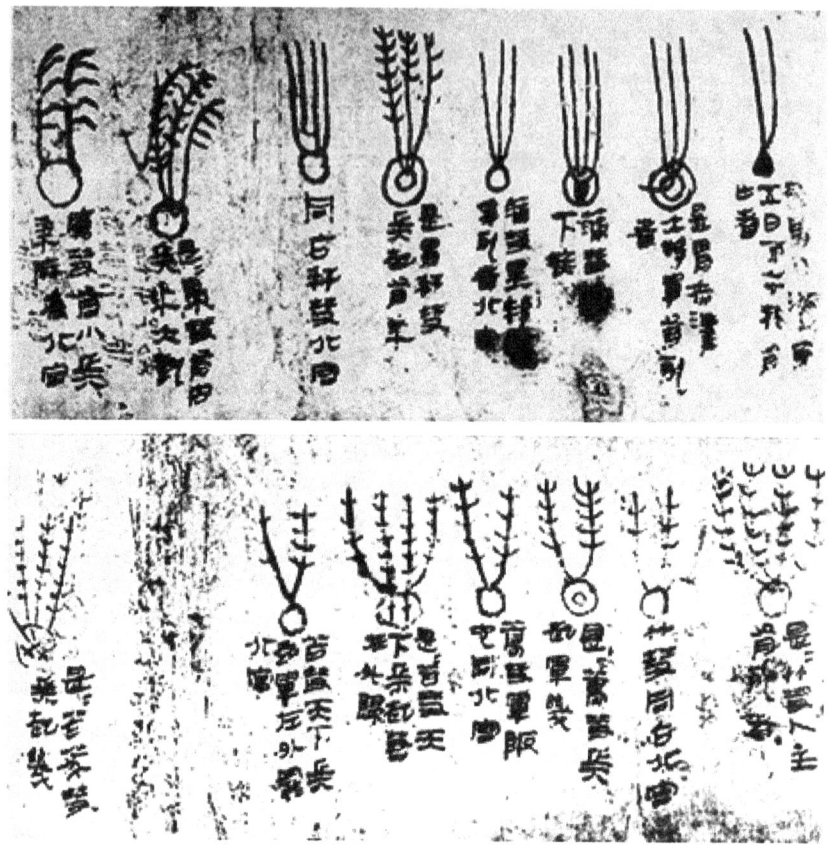

The Mawangdui silk, discovered in an ancient tomb uncovered at Changsha in south-central China, with a "catalogue" of comets compiled sometime around 300 BCE, but the knowledge it encompasses is believed to date as far back as 1500 BCE, that is, 3,500 years ago.

Comet

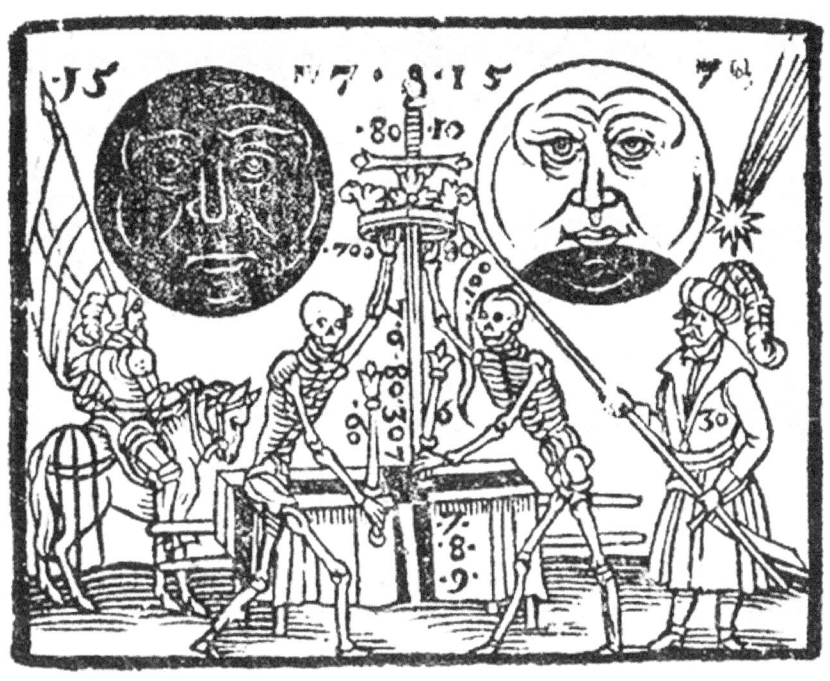

Skeletons with comet. Probably related with the passage of Halley in 1607. Comets were often associated with destruction and death.

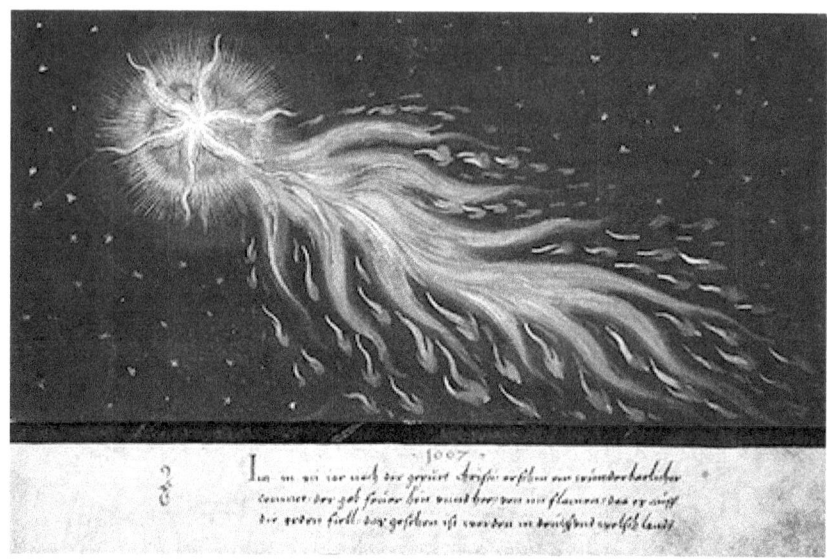

"In 1007, a wondrous comet appeared. It gave off fire and flames in every direction," The Book of Miracles, printed in the 16th century.

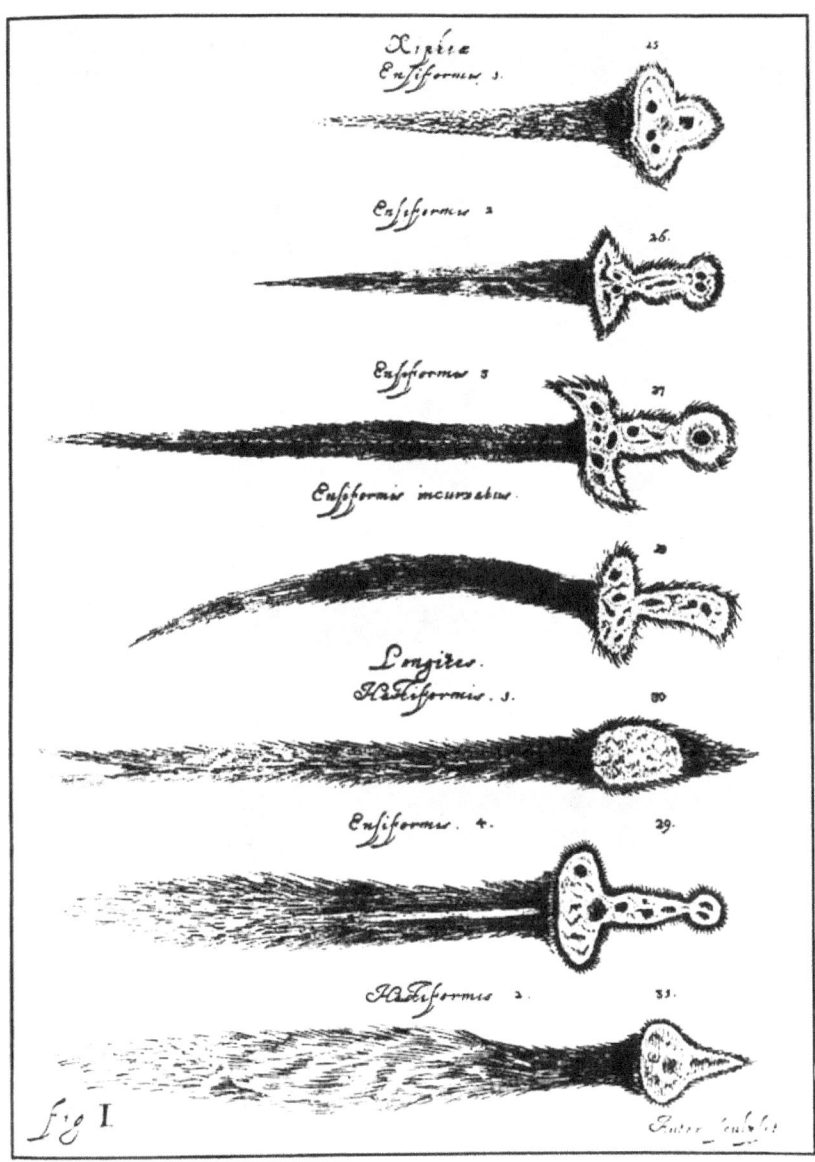

Cometographia, illustrations by Johannes Hevelius, Danzig, 1668.

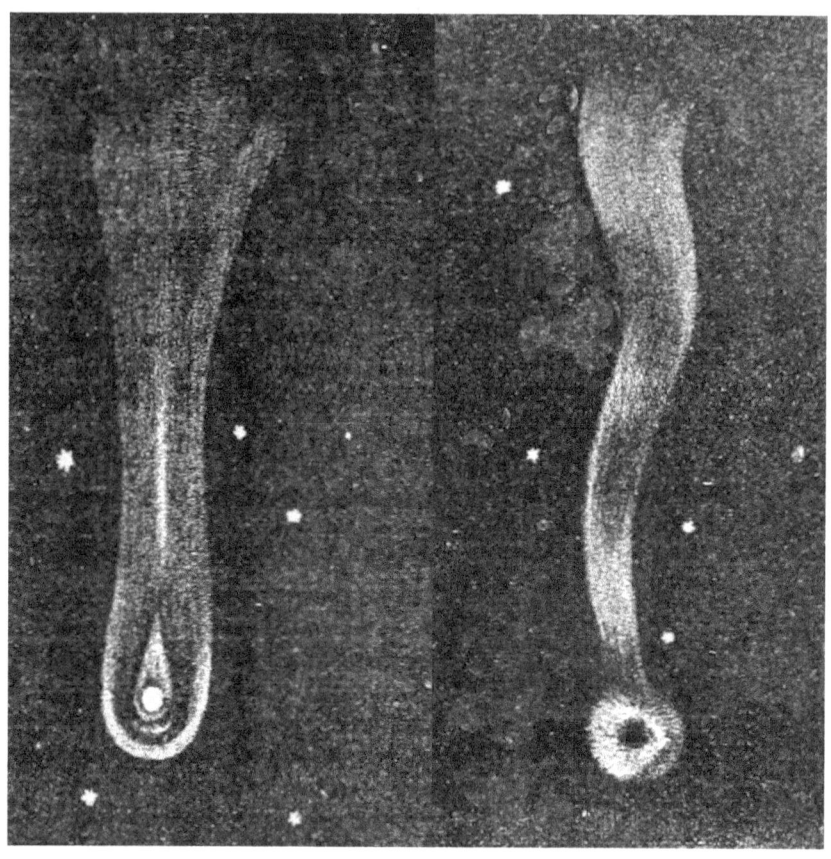

Two illustrations of Halley comet, 1759 and 1682.

Comet

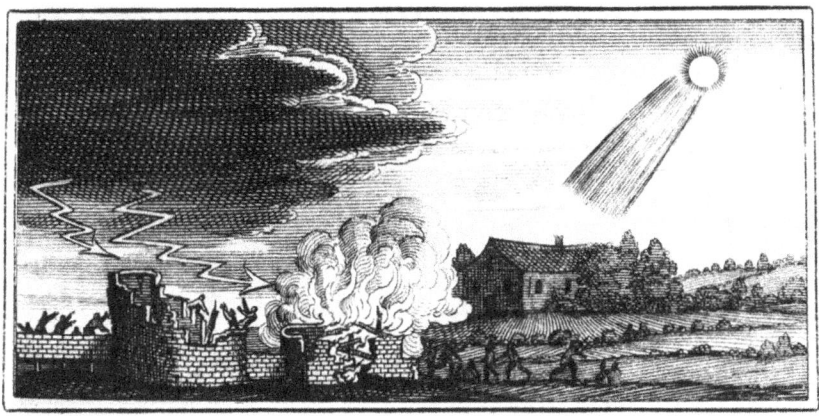

Woodcut with the destructive influence of a fourth century comet from Stanilaus Lubienietski's Theatrum Cometicum, *Amsterdam, 1668.*

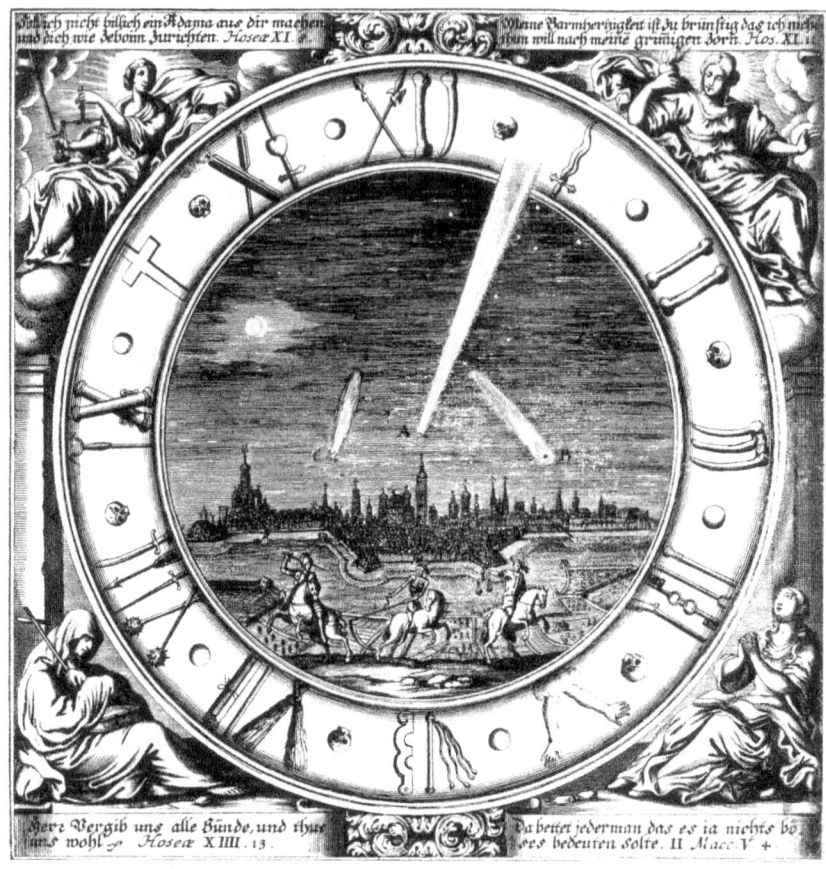

German illustration shows a view of Augsburg, Germany, with the comets of 1680, 1682, and 1683 in the sky.

Comet

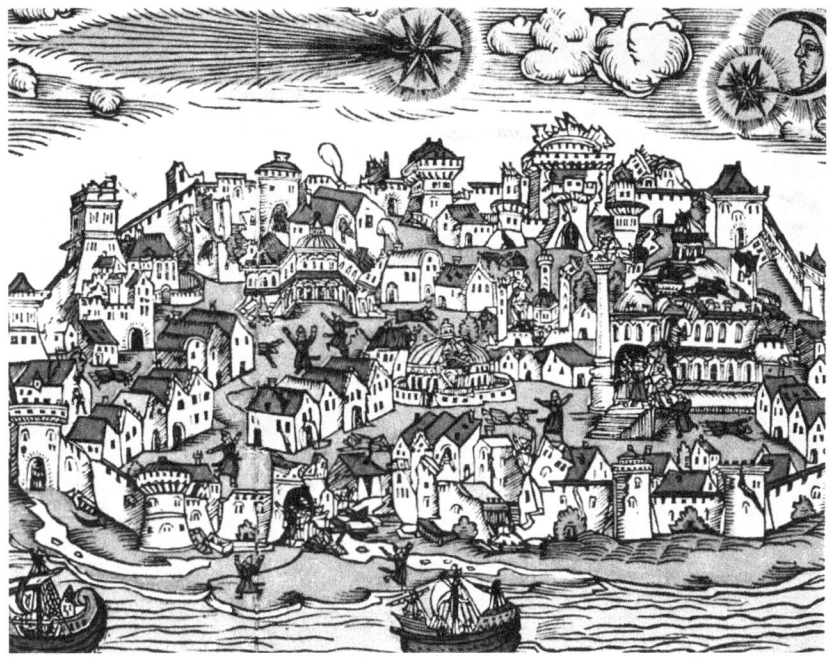

Woodcut illustrating the damage in Istanbul from the May 10 1556 earthquake. Hagia Sophia dome and other buildings were heavily damaged, with many fatalities. A comet was sighted on March 5, 1556.

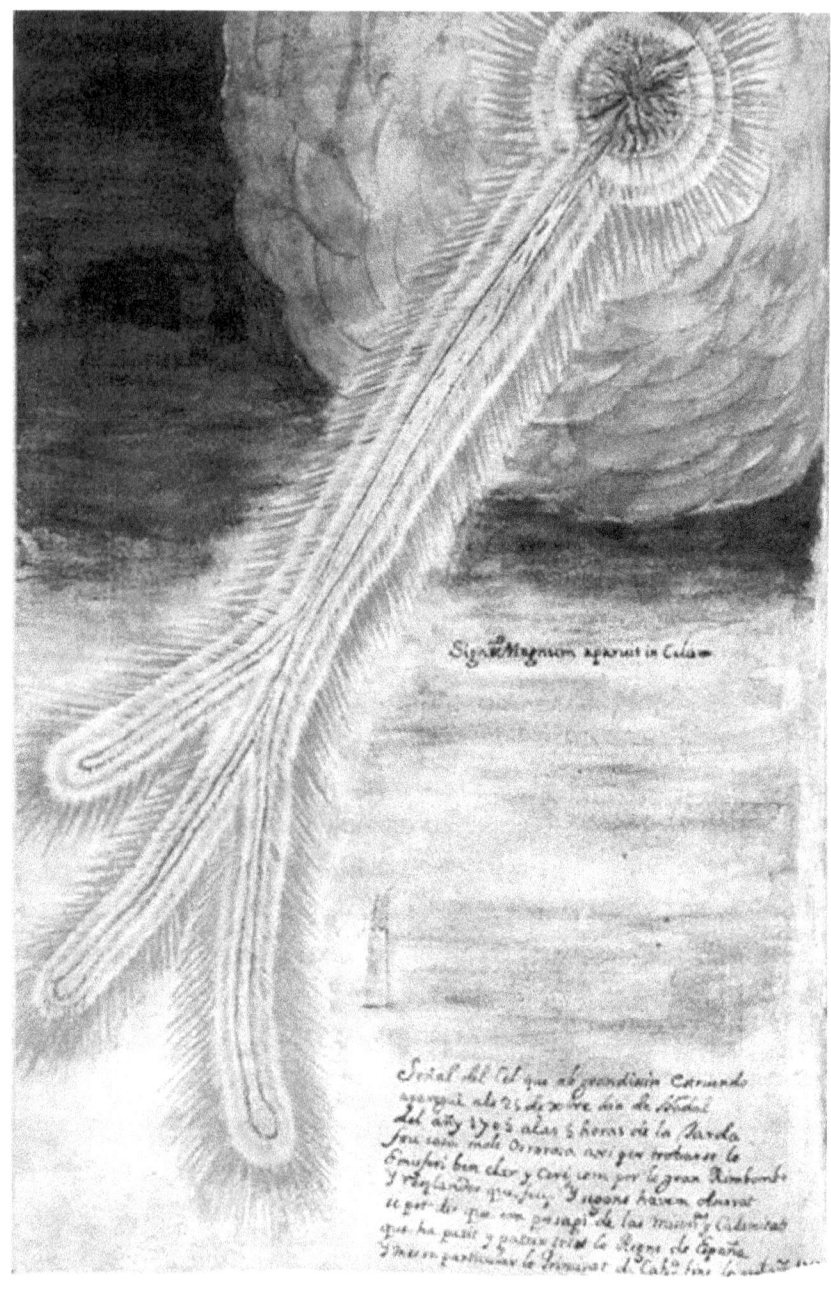

On Christmas day 1704 a great light appeared in the sky of Catalonia.

Comet

Why we need to go to space? For one because it is in the path of evolution. We are the product of the universe. Mountains, valleys, the oceans, volcanoes, our own bodies as well as the smallest bacteria are made from stardust. We came from stars and to stars we must go back. But today there is a more pressing reason. As an intelligent species we did not behave very well so far. Humanity was never able to think itself as a temporary organism subject to the laws of nature. We destroyed the same environment that made possible our existence. Most probably in an irreversible way. We exterminated many of other life forms and with them the sustainability of our own. It is not very clever. Actually, it is very stupid. We are now seriously facing our own annihilation. By mass extinction, global warming, nuclear war, a cosmic catastrophe such as an asteroid impact that we anticipate but for which we did not prepare in time, or whatever it may happen.

Space colonization is easier said than done. The nearest extrasolar probable planets are so far that would take hundreds or thousands of years just to arrive there, depending of the spacecraft speed. Travelling near the

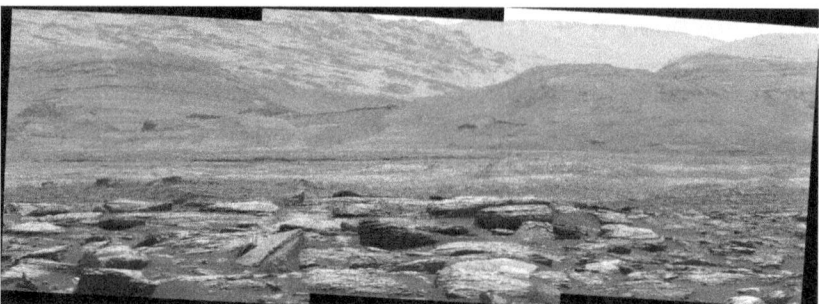

Mars photo taken by Curiosity robot, 2016. Image Credit: NASA/JPL-Caltech/MSSS

speed of light is for the moment absolutely out of question. And it may stay in that way. Otherwise we would had already the visit of extra-terrestrial beings. The fact that it didn't happen may be related with the immensity of the universe. Travelling in space is not compatible with lifeforms, such as ours, that live for decades. We may live a few centuries in the future but it is still short. Proxima Centauri, in the constellation of Centaurus, is the nearest star from the Sun at the distance of 4,22 light years or 9,46 trillion kilometres. At the fastest speed achieved by a current spacecraft it would take 80.000 years to get there. 80.000 years ago, mankind was still in Stone Age…

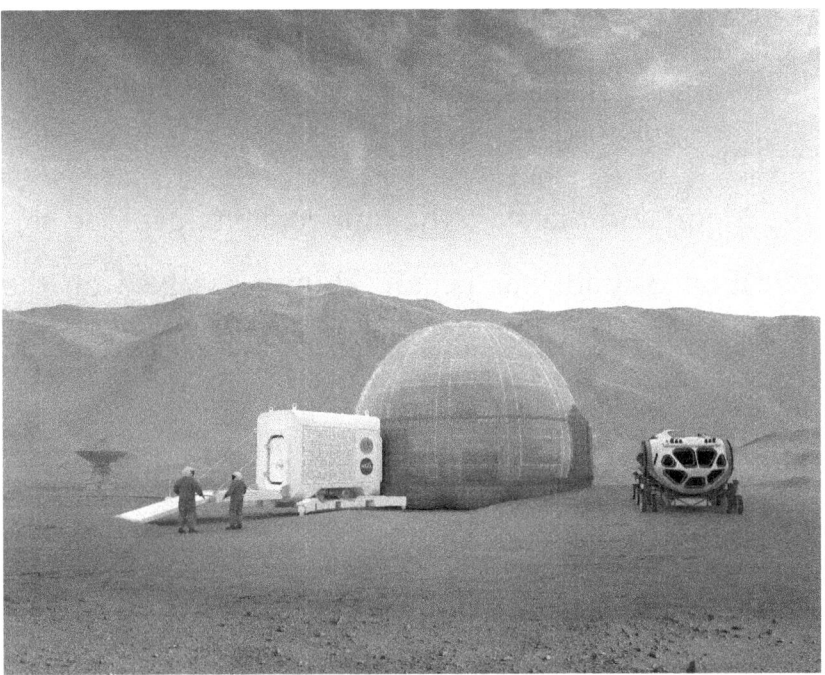

A 3D rendering of a Mars home concept. Image Credit: NASA/Clouds AO/SEArch

Hence, extrasolar colonization may prove impracticable for a long while. At least if we think of a large exodus like we see in some sci-fi movies were almost everyone escapes the Earth after a catastrophe. We are 7,7 billion and rising. In 2050 will be 10 billion reaching the limit of planetary sustainability. How many people could go and where? Unless we see it as a kind of panspermia, sending small groups of humans to far and remote places as

a seed to never come back, a generalized programmed migration is not viable. In brief, we are stuck in our solar system.

The Moon and Mars are the immediate target. The colonization of both has begun. Humans walked on the surface of the Moon and projects of colonies are being designed. In Mars, robots, with witty names as Opportunity or Curiosity, were the first explorers. Humans will follow soon.

Among other things robot explorers are extremely important for AI evolution. A robot dropped in a far and hostile environment need to be able to evaluate conditions, take decisions, have a great if not total autonomy. A radio signal between Mars and the Earth has a delay from 4 to 24 minutes depending on the relative position of the two planets. This means that robots cannot be operated in real time from Earth. Unless the robot lay still for several minutes it is not possible for the human operator to take a photo from a particular Mars-scape. Or perform a specific localized task.

Robots are the new explorers. Robot autonomy is essential for space exploration and it boosts AI development.

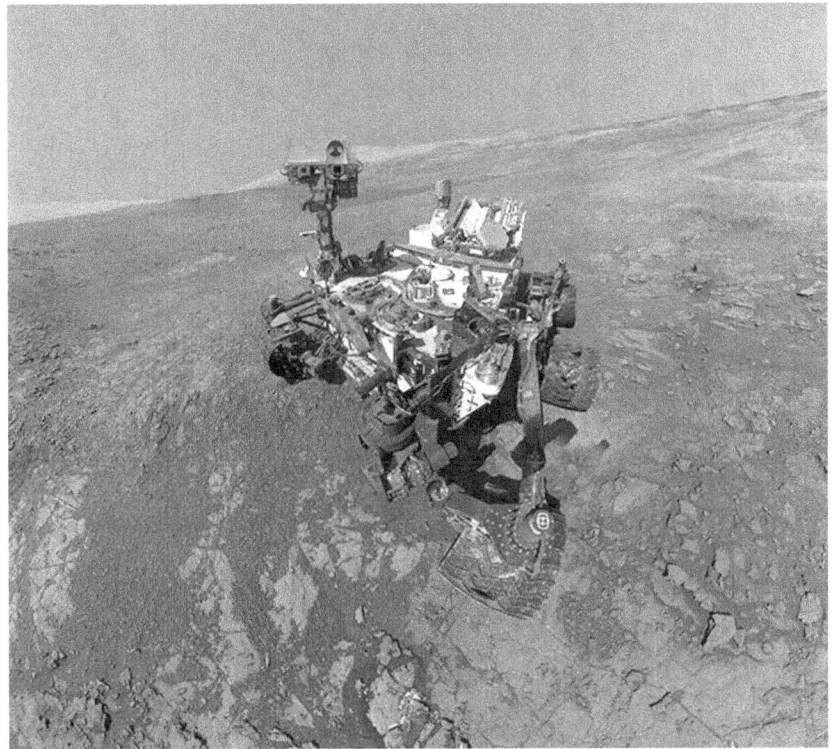
The new Vasco da Gama. Image Credit: NASA/JPL-Caltech/MSSS

Space exploration literally opens our horizons. We are no longer just terrestrial but also extra-terrestrial. This new condition should give humans a greater sense of responsibility and purpose. Unfortunately, space exploration is generally seen by the media as fait divers, a trivial competition between nations.

Art can help.

My Artificial Comet is a new kind of work of art that envisions the future of humans as space explorers. It gives visibility to the ongoing space exploration. On October 4, 1957, the soviets launched Sputnik 1, the first satellite. Since then more than 8,000 from 40 countries have followed. Most orbit the Earth. Some are already very far from our planet. Voyager 1 is now over 21 billion km away. Soon humans will colonize the Moon and Mars. A higher global conscientiousness of the challenges, goals and ethical implications are needed.

The Artificial Comet delivers a clear message of unity of mankind. Altogether, with no exceptions, we are the inhabitants of a singular planet and share the same endeavours. We are also, collectively, responsible for our common future. Space explorations is probably the last chance to redirect the evolution of human society to a more rational approach. Instead of wars, famine and discrimination, we should be occupied with solving the immense but fascinating problems that becoming extra-terrestrials demand.

In the information age, and the noise it generates, we need clear, objective messages. May they be easily un-

derstood and mobilized especially those who wish to do something meaningful with their lives. Space exploration is an adventure and a destination. It is in our day a correspondent of the time of the Discoveries. Let us be worthy of this fantastic opportunity.

Needless to say that as an artist I like the idea to look at the Universe as a gigantic canvas where I can paint a small but meaningful brush-stroke.

Leonel Moura

Leonel Moura is a European artist born in Lisbon, Portugal, that works with AI and robotics.

In 2001 he created the first robot arm able to generate unique paintings operate by an 'ant algorithm'.

In 2003 a swarm of 'Painting Robots' were able to produce artworks based on simple rules and emergent behavior. Since then he has produced several artbots, each time more autonomous and sophisticated. RAP (Robotic Action Painter), 2006, created for a permanent exhibition at the American Museum of Natural History in New York, is able to generate highly creative and unique art works, to decide when the work is ready and to sign it, which it does with a distinctive signature.

ISU (The Poet Robot), 2006, generates poems and paintings with letters and words.

In 2007 the Robotarium, the first zoo dedicated to robots and artificial life, opened in Alverca.

Other works include 3D sculptures, interactive installations and the play R.U.R. from Karel Capek, with 3 robots performing aside 3 human actors, premiered in São Paulo in 2010.

In 2009 he was appointed European Ambassador for Creativity and Innovation.

Comet

Bebot Association, 2019

www.ingramcontent.com/pod-product-compliance
Lightning Source LLC
Chambersburg PA
CBHW081646220526
45468CB00009B/2572